CHILDREN

around the

WORLD

by Leo Buijs

Second edition 2016

National Library of Canada Cataloging in Publication

Buijs, Leo,
 Children Around the World/ Leo Buijs.

ISBN 978-0-9735527-44

 1. Photo journalism. 2. Children photography- World. 3. Photo book- UNICEF. 4. British Columbia--Travel. I. Title.
II. Title: Children around the World.

This photo-book is published by Seaview Investments Ltd.,
219 Spindrift Rd., Courtenay B.C. Canada

E-mail; leobuijs@yahoo.ca

Front cover: a class of schoolchildren at the Hong Kong Museum of Art
Back cover: a young boy walking along a dirt road near Hanoi, Vietnam

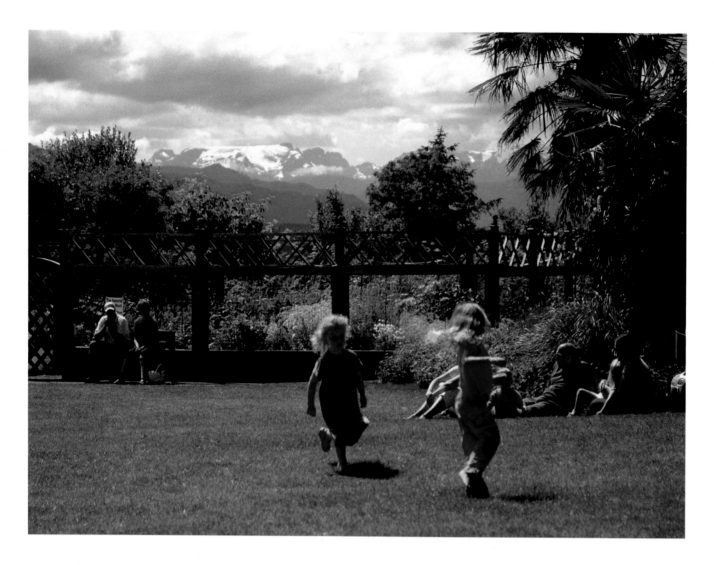

Two girls dancing their heart out on a summer afternoon on the lawns of the Filberg Heritage Lodge
in the Comox Valley, my home turf.
In the background the slowly melting Comox Glacier, British Columbia, Canada.

Introduction

Over the years of travelling with my spouse to different parts of the world, I always made sure I had my camera ready. Besides taking pictures of the so called 'sites' I often got moved by the faces of children, wherever they were in this vast world of ours.

From South America, Africa to Asia, Europe and everywhere in between it is fascinating to see how children of the world express their joy under circumstances that differ greatly from place to place. Still, most of them wear happy faces, unlike the ones you see on TV, breaking your heart to open up your wallet for support. Therefore this book has mostly happy faces wherever I could find them.

There were only a few children on the Galapagos Islands, but the rest of Ecuador, Peru and Amazonia certainly made up for that. At the other side of the globe, in the Russian Gulag archipelago, a simplicity of life was everywhere on the surface, but the children looked just as happy. In other places such as Vietnam and Laos, a spark of prosperity showed in these children s' attitudes and faces, while closer to home, in Mexico and Canada, kids seem to look equally cheerful.

The photographs are taken over a time period between 1995 and 2014, often depicting the living circumstances or entrepreneurial instincts of children. At other times they just show innocent and happy faces.

As you peruse through the pages, I'd like to take you on a journey to become intrigued with the variety of captivating photographs of children, and I hope you will enjoy the ride.

Now don't be fooled, life for children around the world is not all rosy and pretty faces. I have seen enough despair and poverty, so I have committed myself at the outset of creating this book, to donate 10% of the book's revenue to UNICEF Canada. They know how to use the funds in an effective way to alleviate the suffering of children wherever they feel the need.

On behalf of UNICEF, I'd like to thank you for your support.

Leo Buijs

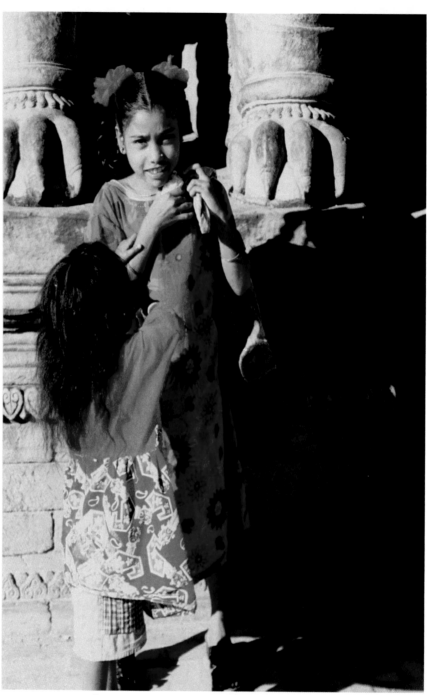

Two girls playing at the entrance
of a temple in Bhaktapur, Nepal.

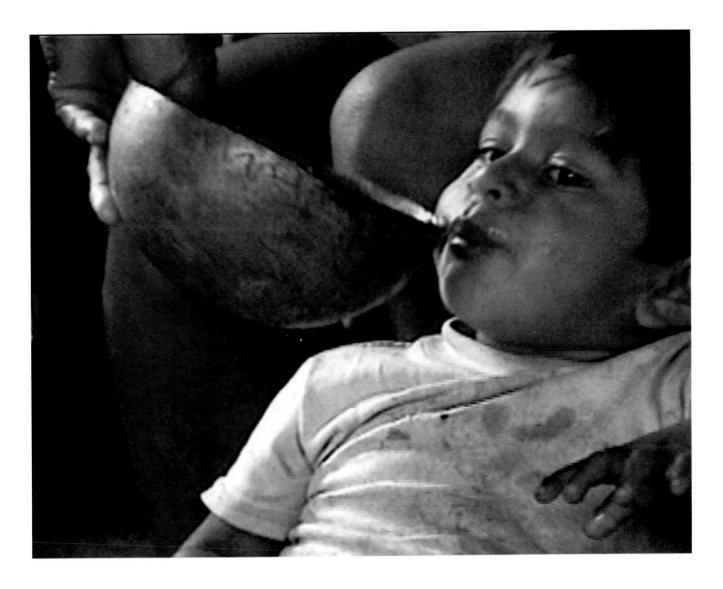

In Amazonia, after driving a curvy pass-road over the Andes, we came down to a very primitive homestead along a tributary of the Amazon river. This is where we found little Serge who was fed a home-made brew.

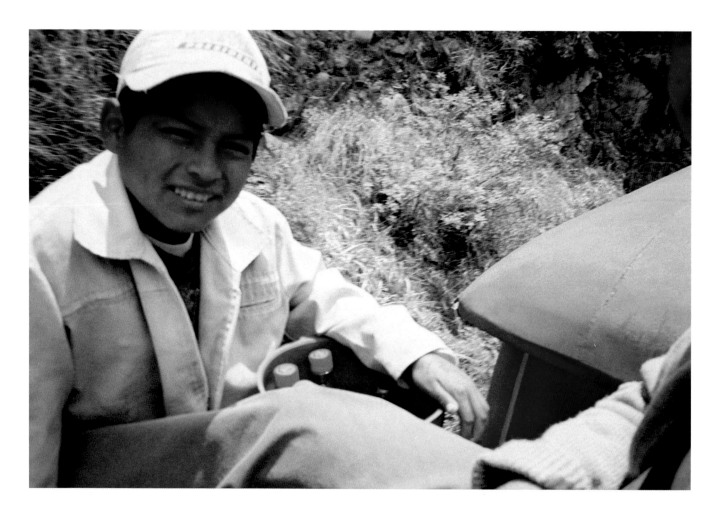

The most entrepreneurial kid we came across was in Ecuador.
Riding on the roof of an old steam train through a narrow canyon, this kid was selling us Coke and
water while just barely hanging onto the train's roof.

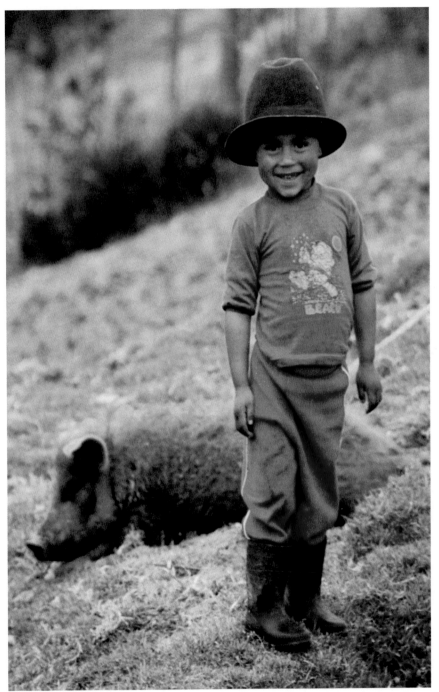

This is my favourite country boy
in Ecuador.
While hiking to an old mission
we ran into Juan and his pig.
As you can see, he was a super
photo 'model', very relaxed,
perhaps because of the splendid,
and clean Andean mountain air.

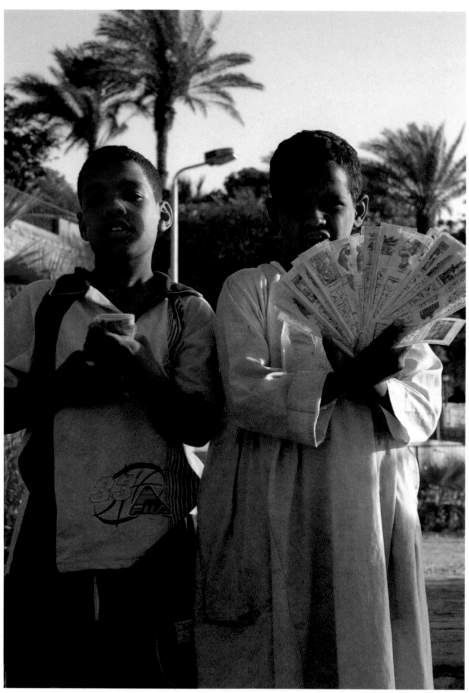

Egyptian boys are very clever and business like. In stead of buying something from them, I asked them to get me some beer, something that is hard to find in a Muslim country. When they came back with a few bottles, I tipped them handsomely.

This photo was taken near the edge of the Nile river in Aswan, Egypt.

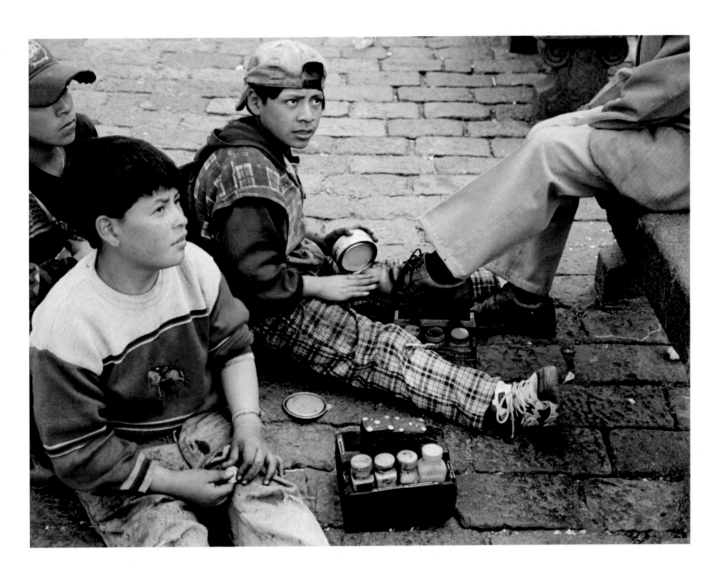

Shoe-shine boys at the large Plaza de la Independencia, Quito, Ecuador.

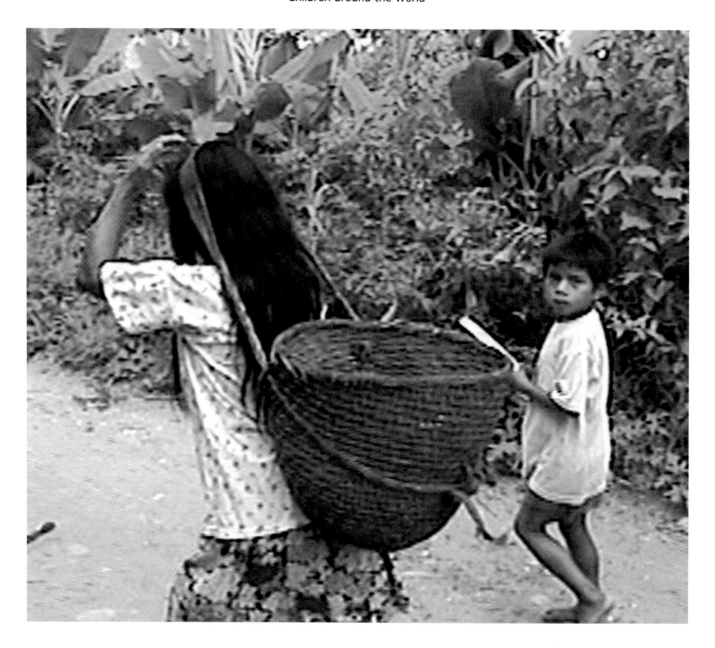

Children put in their share to alleviate the laborious circumstances in Amazonia.

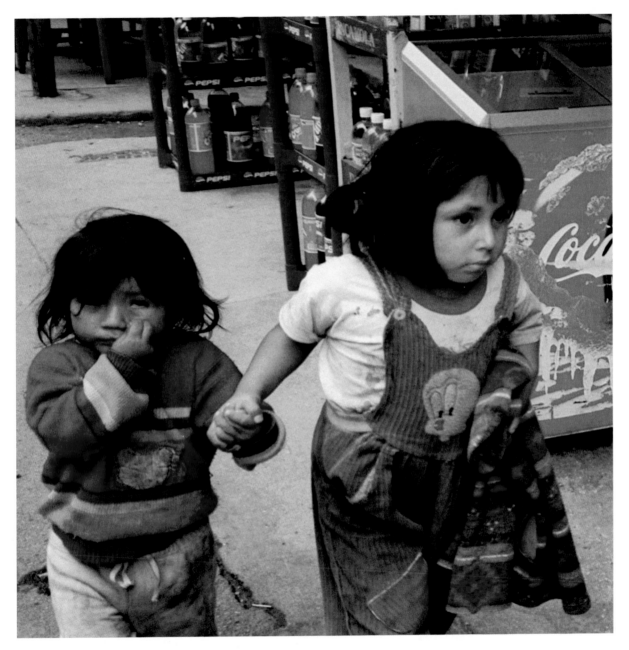

One sad face and a caring sister on a street in Aqua Caliente, the small town at the foot of Machu Pichu, Peru.

These two sisters waiting to cross the road in a small town near Otavalo Ecuador were so adorable, even before I photo-shopped them with a water-colour effect.

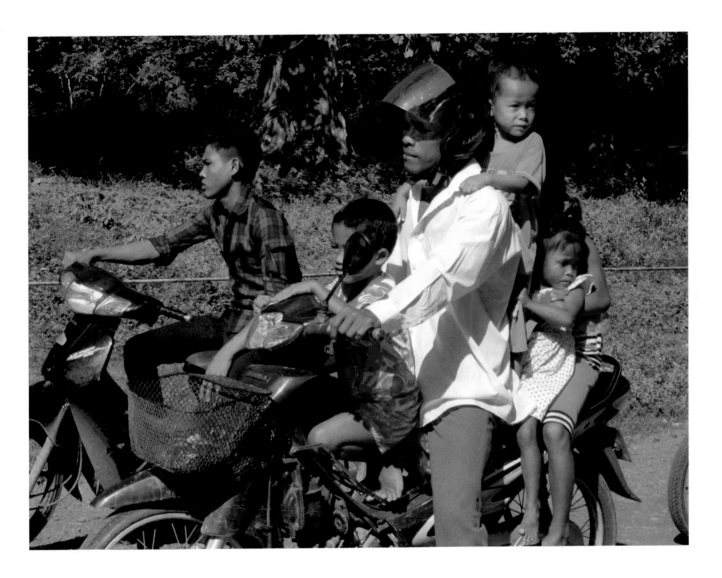

Not very safe perhaps, but surely an inventive way of travelling for those four kids on a motorbike with daddy. Phnom Penh, Cambodia.

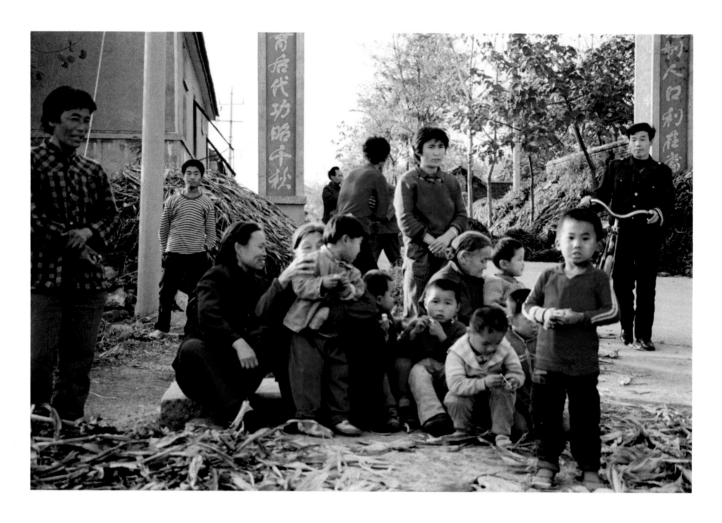

Not long ago in China, I had the chance to visit a traditional commune where the kids seemed very happy with their old fashioned toys and way of life. As it was fall, scents from dying leaves, smoke from cooking, as well as the happy children, left a marvellous imprint on my senses.

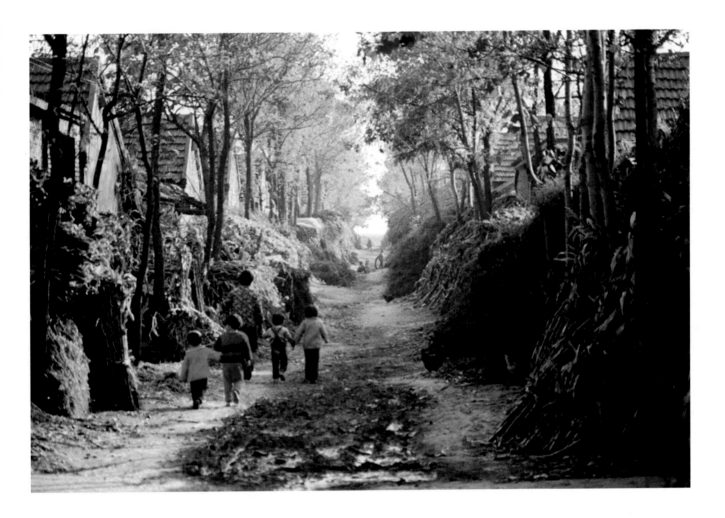

Still, at the same village, the living circumstances for those children were unbelievable.

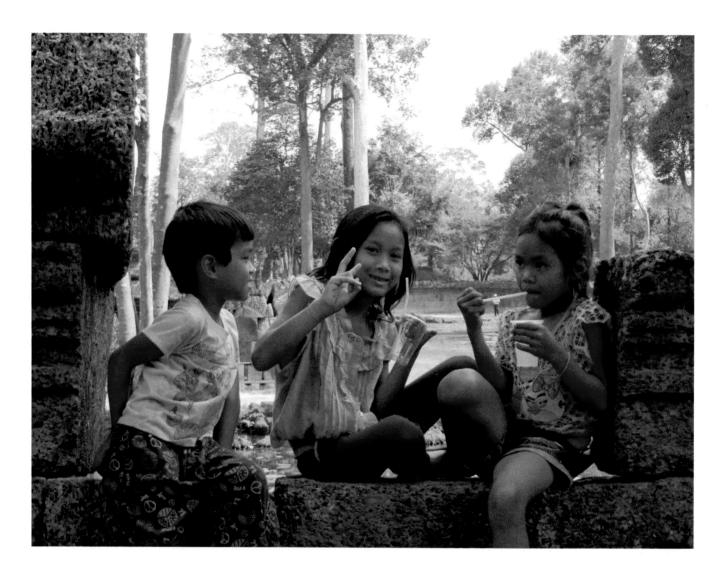

These children have good reason to be happy as they have obviously reaped a decent way of life, due to the millions of tourists spending hard currency at the majestic splendour of Angkor Wat in Cambodia.

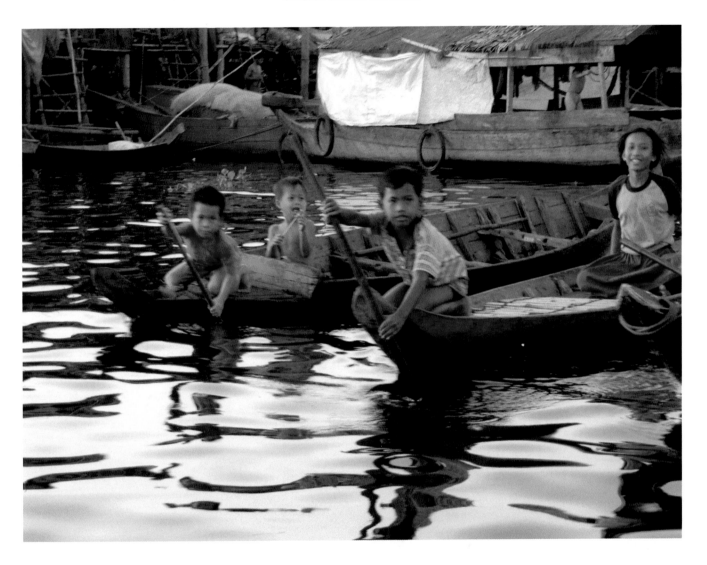

As they live in a floating fishing village on Lake Tonle Sap, Cambodia, these children are masters at manoeuvring their boats

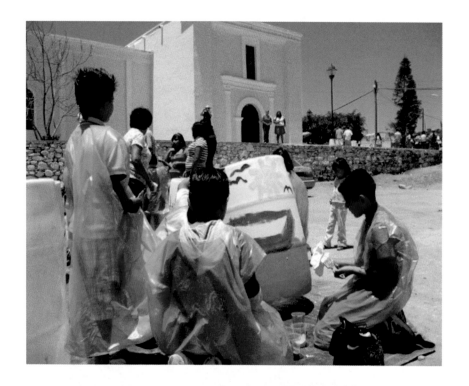

Children in Todos Santos, Baja California Sur Mexico, are very creative, thanks to the little town's many artists who organize and support many events throughout the year.

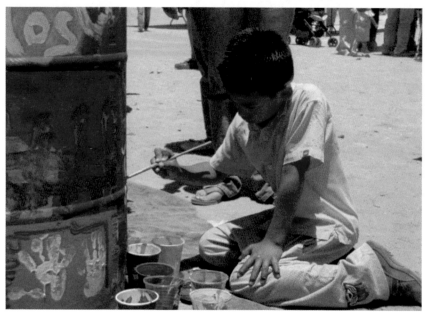

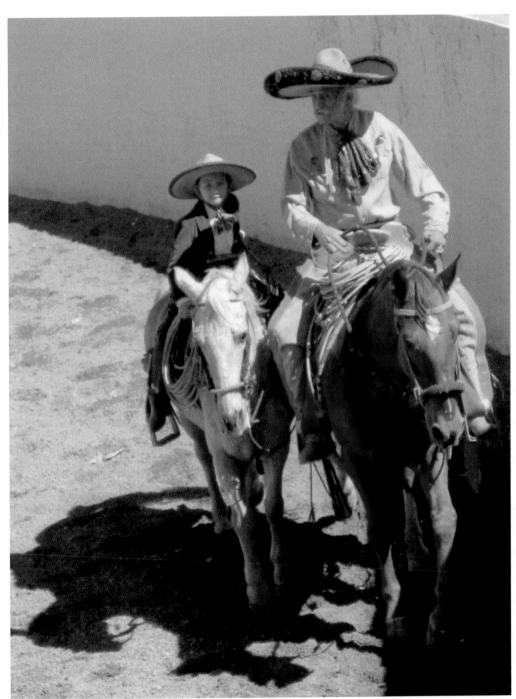

How wonderful to ride a horse with your grandpa on your side. Just outside San Miguel de Allende, Mexico

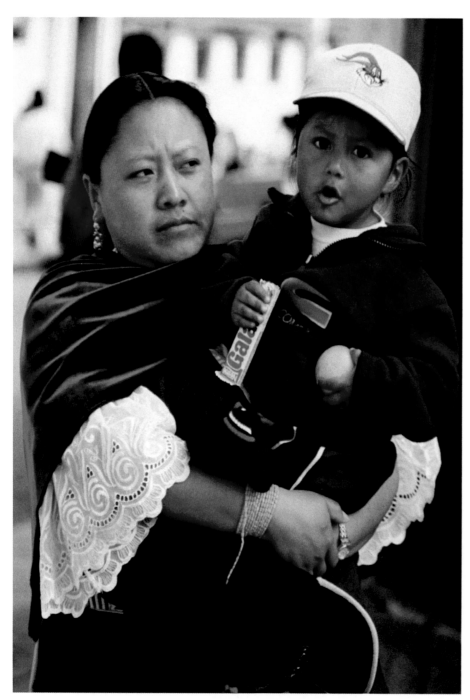

Mother in traditional dress from Otavalo Ecuador, and her child obviously proudly 'westernized.'

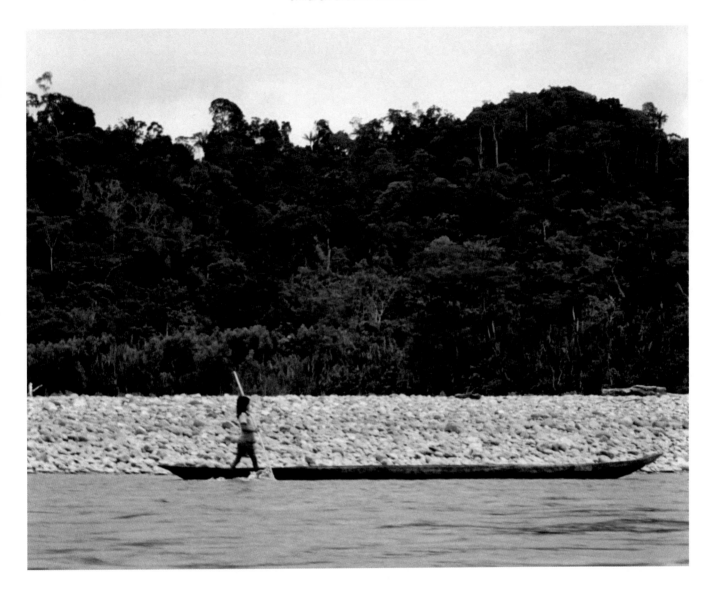

Little girl, big canoe.

All by herself on this fast running contributory to the Amazon river.

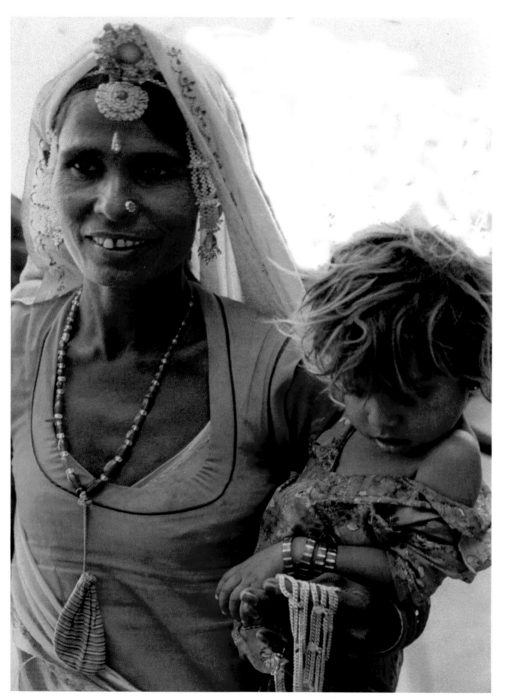

The mother of this child is selling trinkets. Making a picture from them puts extra money in her pocket and I just hoped she would use it wisely, to benefit her child. Jodhpur, Rajasthan, India.

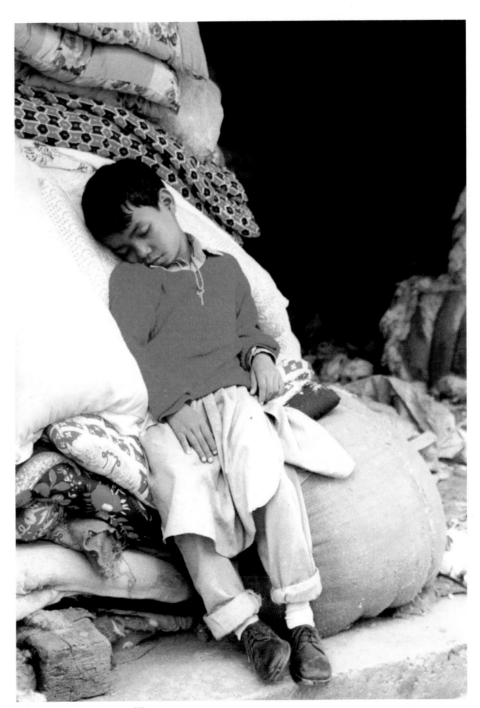

In a market in Pokhara,
Nepal, this little boy was
sound asleep.
Look at, presumably, the
house-key, around his neck.

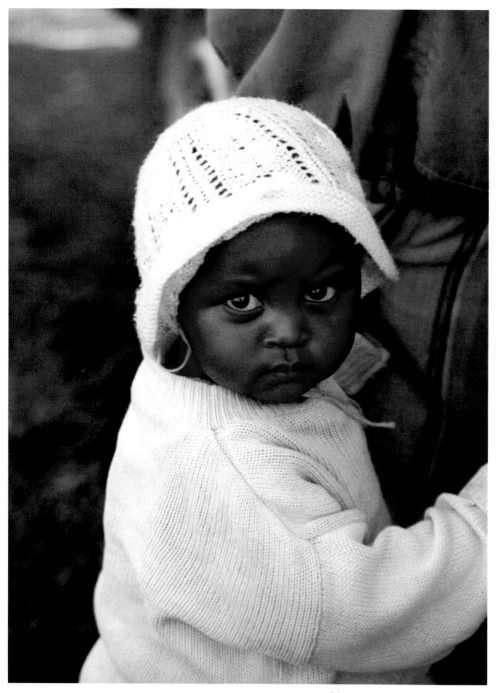

This beautiful girl's name is Akeyo, meaning 'born during the harvest'. I ran into her while visiting a coffee plantation in the high Aberdare Mountain range, on our way to the famous Tree Top Lodge, which stands next to a waterhole in the Aberdares game park. This is the same place where Queen Elizabeth stayed in 1952 and heard the news that her father King George VI had passed away. She was proclaimed Queen of England instantly.

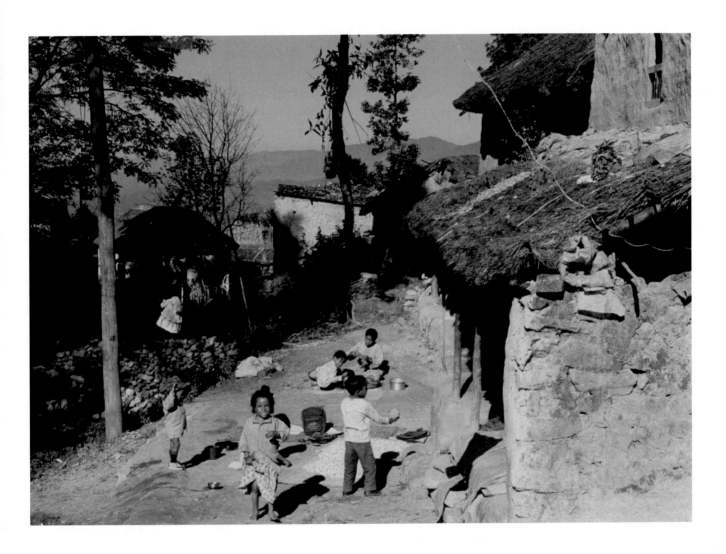

This is 'main street' in a village down from Nagarkot, Nepal.
The children tried to collect a toll as they were blocking the road.

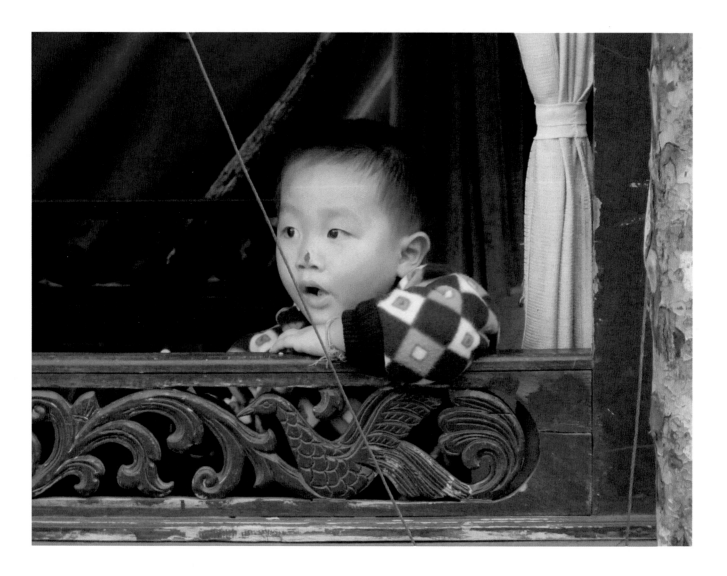

This intriguing boy just peaked out of the window of a traditional Mekong river boat when we departed for our trip down-river in northern Laos.

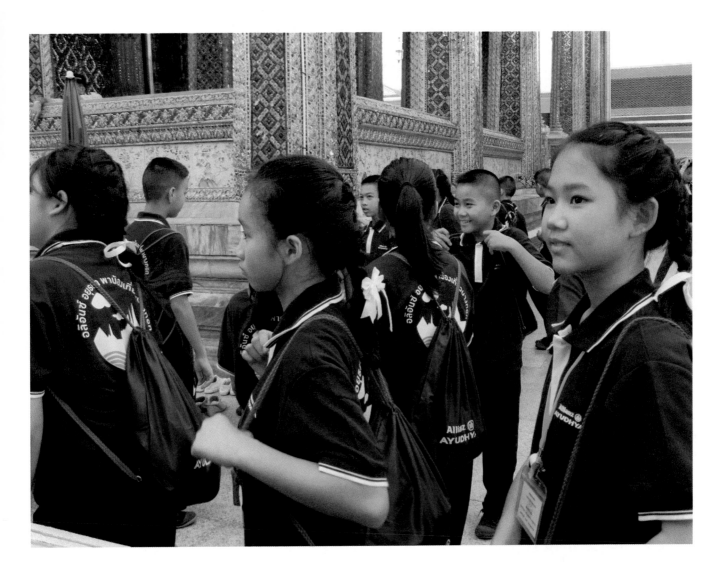

Students visiting the grounds of the King's palace in Bangkok Thailand.

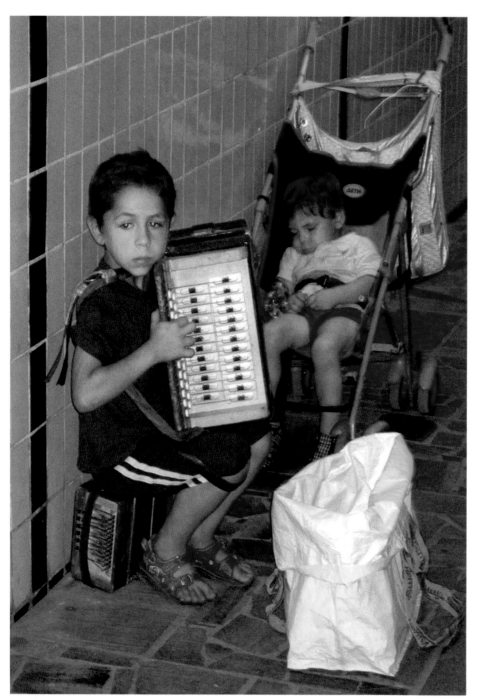

It's a pity that some children are exploited by begging for change from anyone passing by.
This boy, in an entrance of the Moscow subway near the Kremlin, was doing three things at once: making music, taking care of his baby sister and collecting handouts.

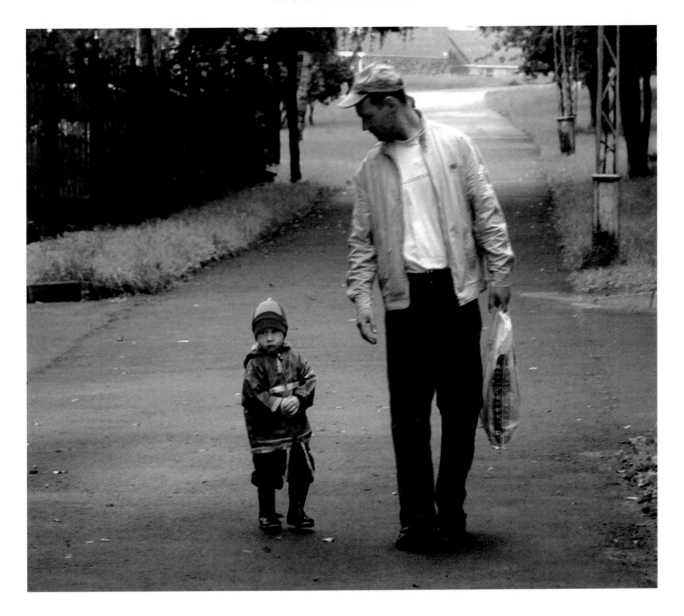

For a change, father and son.

Walking down the street in a rural town in northern Russia.

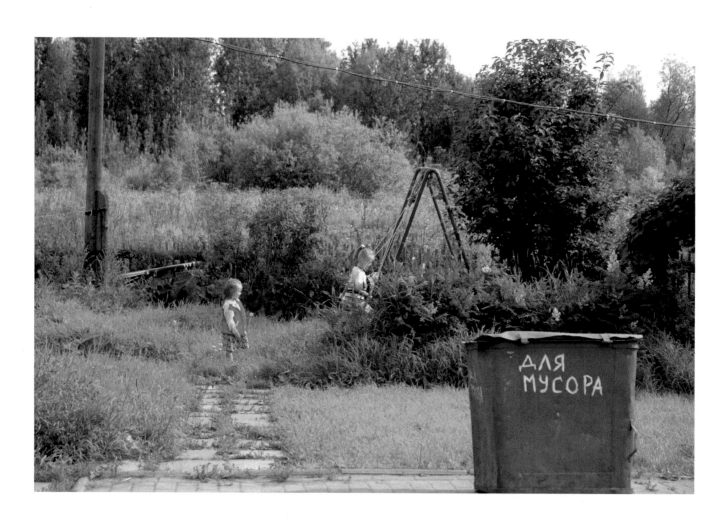

Simple, old-fashioned entertainment in a backyard near Murmansk, northern Russia.

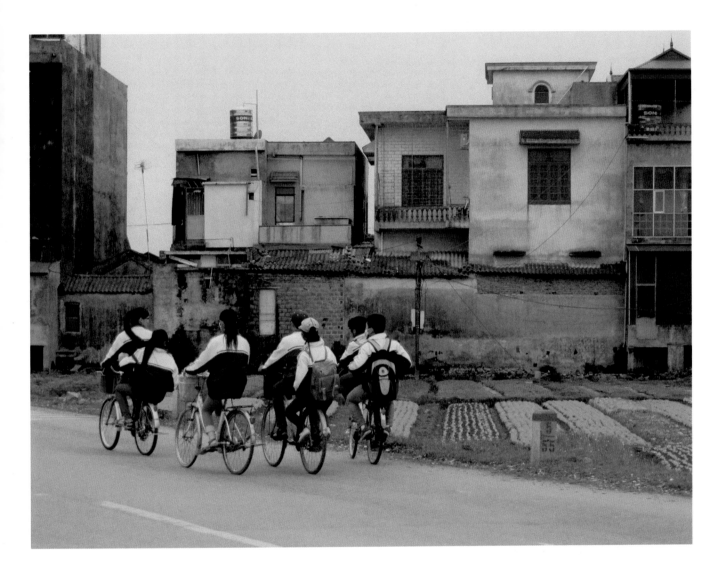

School kids on the way home, outside Hanoi, Vietnam.

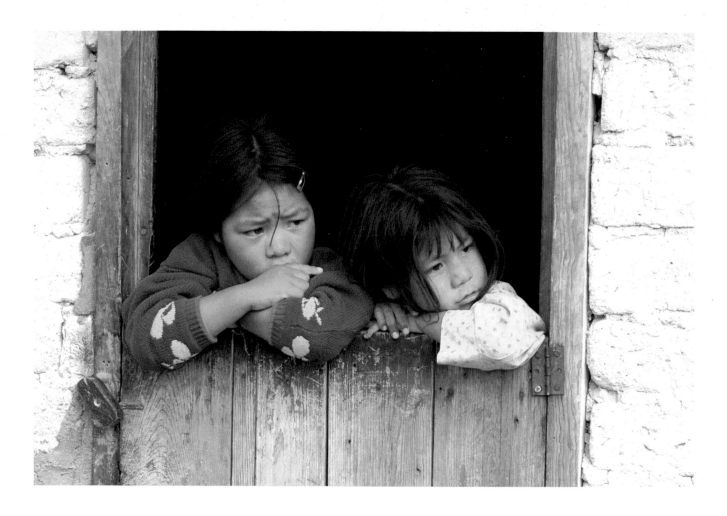

Sisters at the door.

Some rustic living quarters in the heart of Copper Canyon, Sinaloa State, Mexico.

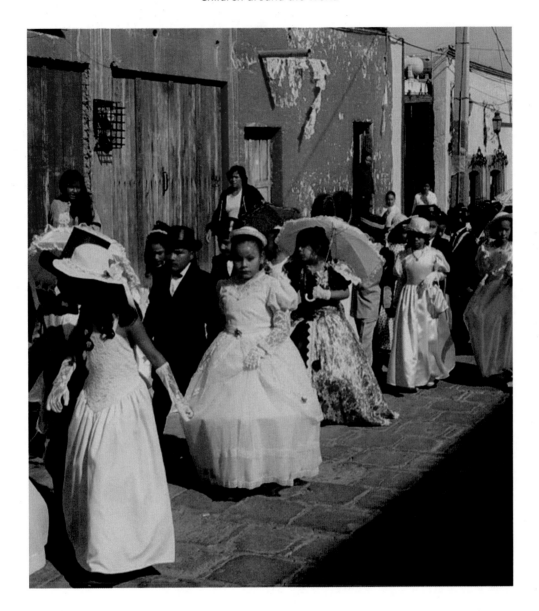

Same country, different State.

All dressed up for 'Dia de Revolution' (revolution day, November 20) in San Miguel de Allende, Mexico.

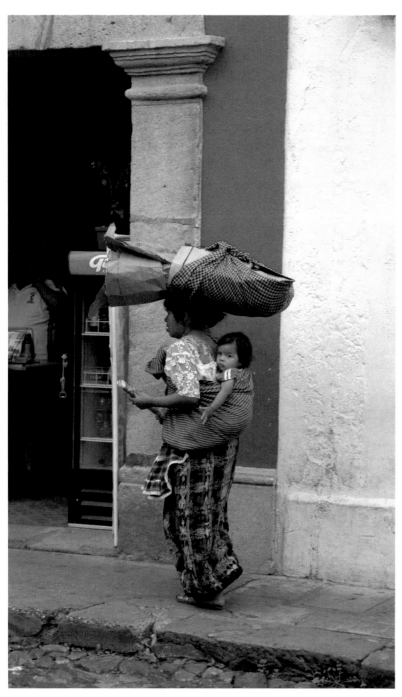

Quite a load for this mother to carry around.

This is in Antiqua, Guatemala.

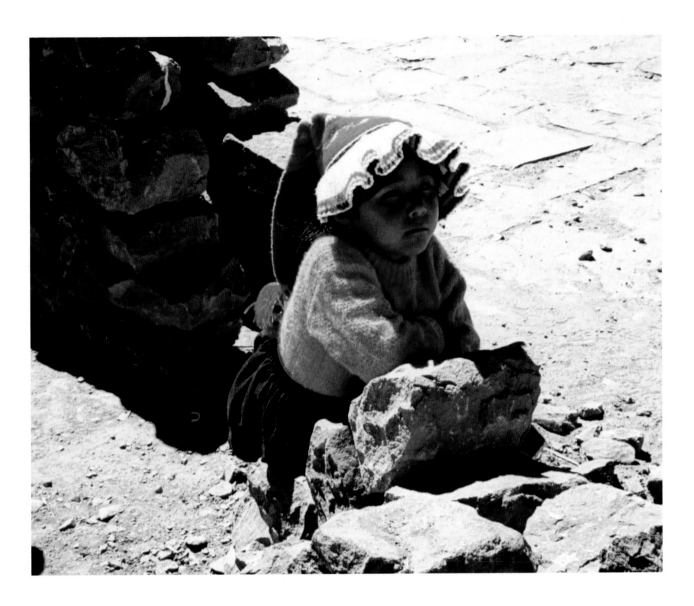

Sunday girl on Taquille Island, at 12,500' in the middle of Lake Titicaca, Peru.

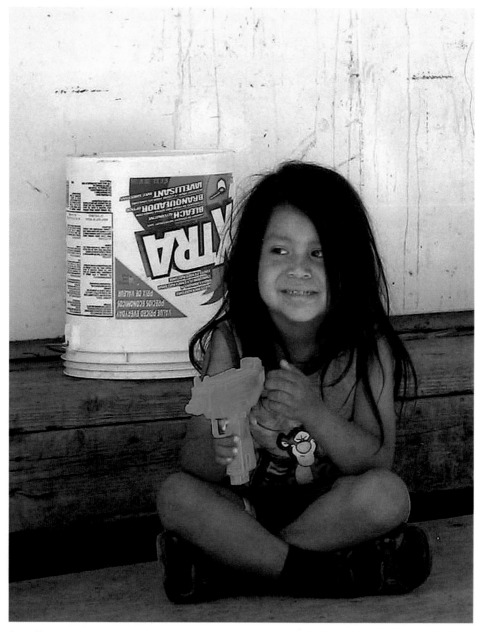

This aboriginal girl's name is Baby Darling. She is playing with a water pistol as it was a very warm day in Skookemchuck, Skatin First Nations, British Columbia, Canada.

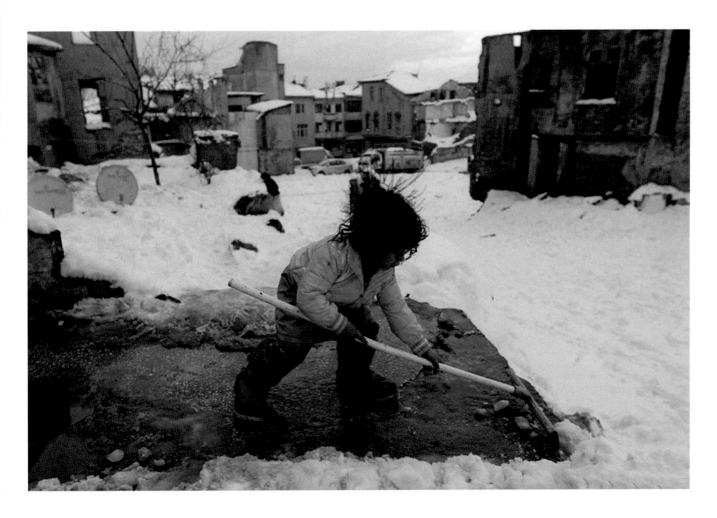

This last picture is the only one in this book not taken by myself.

The honour goes to someone at Europe world press. It is a harsh reminder that many children have a difficult future ahead. This Syrian refuge child is doing its job in Istanbul, Turkey.

About the author, photographer

Born in the Netherlands, Leo Buijs immigrated to Canada in 1978, with his wife and two boys. He used to live in Victoria and moved to Courtenay B.C. Canada, where he lives now with his wife and his Dutch Sheepdog Femke.

In 2003 he wrote '50 Best Dog Walks around Victoria' which sold out very quickly. After his move up-island, the first print of 'Best Dog Walks on Vancouver Island' appeared in 2006 followed by a second print in 2008. In 2010 he published the very popular 'BEERS of British Columbia' book. A guide about Micro-breweries and Brew-Pubs. His foremost passion is travel, and often takes his dog along the way. He also loves to sail and write. An updated and revised 'Best Dog-walks' edition is his third book on the subject. Some of his other work was published in Whistler's *'Pique Magazine'* and he was a regular contributor to *'The Gringo Gazette,'* an English language paper in Baja California. His first award winning photograph was in 1999, when he was featured in the June issue of *'Boulevard Magazine'* with winning photographs from Africa and South America. Ever since he has won more awards with his photos and now he likes to share some of them in this colourful book that he dedicated to UNICEF.

Acknowledgements

First I would like to thank my wife of nearly 50 years, Marianne, who travelled with me to all those remote places to take the pictures. A smaller and previous issue of this book was proofread and critiqued by many relatives and friends for which I am thankful, as they saved me from many mistakes.

In the end however, this is my own product and I apologize for any imperfections, UN-truths or other boo-boos.

Made in the USA
Las Vegas, NV
20 October 2021